PRAISE FOR CIRCUS MAXIMUS

In *Circus Maximus*, David Starkey [...] Rome to be arrested time and again [...] faith of its Catholic art. We have her [...] tion of the ordinary but moments of [...] within the hurly-burly of the ephemeral everyday. And this he renders with great charm, alertness and silken intelligence.
 —Irving Feldman

As he moves through the galleries, streets and churches of Rome, David Starkey contemplates the nature of eternity, mortality, and belief. The artwork he confronts...challenges him to consider human suffering and ecstasy, doubt and faith, heaven and earth, the human condition and the divine reality that may lie beyond it. In clean skillfully written stanzas, the poet shows us what he can do with language that is as precise as it is suggestive. Like Katherine Anne Porter's *Ship of Fools*, *Circus Maximus* suggests a carnival of human vulnerability and folly, as well as the purity of God and His ardent followers. David Starkey is our knowing, reliable, astute guide—not just to the enduring metropolis that is Rome—but to the eternal city of imagination and art.
 — Kurt Brown

David Starkey transforms a sojourn in the Eternal City into the eloquent, evocative, richly detailed poems of *Circus Maximus*. Though tinted with Italian light, the contoured subjects of these subtle meditations—encounters with high art, low street-life, the bustle of time and tourists—are revealed in all their complexity, making for a rewarding, memorable read.
 —David O'Meara

In *Circus Maximus*, David Starkey, like the photographer Dorothea Lange, does not crop the ragged edges off of truth: he demands a true response, not a conventional one. Although the religious subjects of the poems pervade the collection, they never overwhelm the poetry because Starkey's poems are spiritual yet visceral. Aware of the isolation inherent in being human, Starkey explores such contradictions to remind us we must live without closure. Yet in this complex collection, 'nothing ever really douses hope.'
 —Vivian Shipley

David
Starkey

CIRCUS
MAXIMUS

POEMS

BIBLIOASIS

FIRST EDITION

Library and Archives Canada Cataloguing in Publication

Starkey, David, 1962-
 Circus maximus / David Starkey.

Poems.

Also issued in electronic format.
ISBN 978-1-927428-20-7

 1. Rome (Italy)--Poetry. I. Title.

PS3569.T335815C57 2013 811'.54 C2012-907666-X

Edited by Eric Ormsby
Copy-edited by Dan Wells
Typeset by Chris Andrechek
Photographs by David Starkey

Contents

For David Case,
il cuore più grande

Pinacoteca

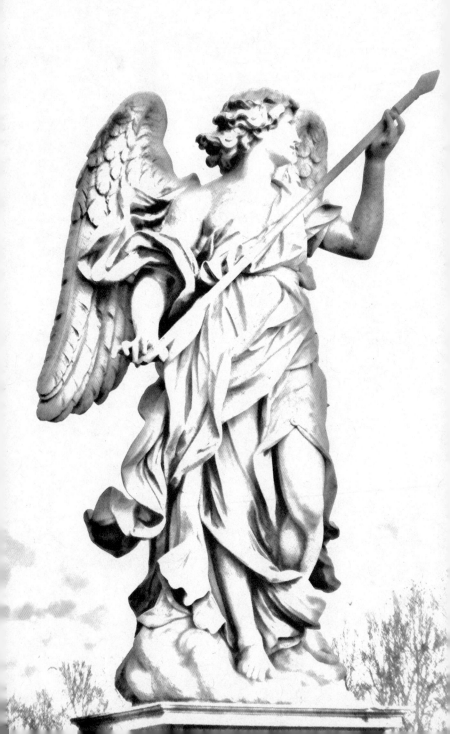

The Son of Man in the Picture Gallery

The Son of Man doesn't want to be petty, but on His way to Calvary
He was far less sickly than they make him out to be.

He shouldered that cross as though it were a piece of kindling.

He didn't whinge.

Not once.

And in the Deposition, why must they always paint Him that
unflattering shade of greenish-gray?

What is it with art?

He'll admit they render His early years with deep appreciation.

As a child, He was adored by practically everyone, especially His
mother.

Our Lady of the Milk.

Madonna of the Straw.

But where's the reverence He knows beyond question is His due?

Who forces people to troop through these stuffy, ill-lit places?

Ragazzi on their mobile phones.

Tourists with faces so buried in their guidebooks they never bother
to see what's on the walls.

They even let in atheists!

Why won't they all just go away, or shut up, at least, and let Him look
his fill in peace?

He's always been a nostalgist, though naturally He can't stand the
silly antecedent gods.

Apollo and his ilk.

He has even less patience with the interminable parade of sour-faced
cardinals and popes.

Frankly, even His most devoted followers are often hard to like.

Peter, who had to go Him one better by hanging upside down.

Sebastian quivering with arrows.

Peevish old Jerome with his pet lion and his stacks of books.

Saint Catherine, who dreamed, perversely, of marrying a nursling.

They are, in general, an unappealing lot.

Only Magadalene really seemed to understand Him.

Noli me tangere: He never should have told her that.

She looked so lovely outside His sepulcher, and almost entirely
 penitent.

Almost, but not quite.

JUDITH AND HOLOFERNES
 —after Caravaggio

It's her first time,
clearly, witness
her incredulity

at how easily
a head is severed
from its body.

But those are the rapt
black eyes
of a quick study:

one senses she could
grow accustomed
to truncating

visiting generals.
The fierce old woman
beside her stands ready

with a rag to carry
the trophy back
to Bethulia—

she's lived long
enough among
warriors to know

nothing about a man
is worth preserving
but his death.

THE DELUGE
—after Michelangelo

How kind they've suddenly all become,
 now the torrent has forced them
 onto the last two stony scraps of land:
father carrying his fainted son,
 husband bearing his wife, mother

cuddling one child while the other clings
 to her leg. Though it's too late—
 it's always too late—they're finally
looking out for one another, cradling
 the weak and sick, reaching

to catch up those floundering in the flood.
 You'd think despair would sound the only note,
but nothing ever really douses hope.
 Just look at that man lugging on his back
 everything he's ever earned,

or those two others, floating a heap
 of plates and bowls on an overturned table,
 as though anyone here still had time
to pause and eat a meal. Meanwhile,
 the lone lucky family sails away

into the welcoming gale on a homemade
 raft, the solitary dove in its dovecote
 beating its wings like a prisoner
in his tower waving goodbye
 to a host of departing friends.

MADONNA AND SAINT ANNE
—after Tommaso Salini

Twelve years old,
just this side
of womanhood,

she sits with her mother,
darning a sleeve,
teeth clenched

as she concentrates
on the next stitch.
Feeding thread

with her arthritic hands,
Anne looks so solemn
in the half-darkness

she surely must fear—
despite their evident ease
with one another

and the haloes
around both their heads—
the angel

about to come
calling on her wholly
unsuspecting daughter.

NATIVITY
 —after Perugino

You quickly forget about everyone
with their hands folded together

in polite prayer—angels airborne
above the manger, pious

shepherds on bended knees,
even the Virgin herself, lovely

as a runway model in her pink silk blouse
and luxurious blue robe—no,

what you remember is Joseph:
his hands drawn back

as though he has just touched a kettle
he didn't realize hung above a fire,

his face that of a man suddenly old,
suddenly too wise.

The Ugliest Jesus in the History of Western Art

Scholars are divided in their assessment
of Filippo Lippi's Quattrocento rendering
of the Christ child as a pudgy grotesque—
not quite an homunculus, but ugly as sin
and too old for the role by decades.

Some say this is a self-portrait.
Others argue the baby resembles
the illegitimate son of the friar
and his mistress, Lucrezia Buti,
a nun. One researcher claims Lippi was simply

drunk. And yet some see *The Tarquinia
Madonna* as a signpost at the beginning
of the Renaissance signaling to painters
who will follow that heresy
is more rewarding than orthodoxy,

that when all the sweet-faced messiahs
are forgotten, this piggish little man-
boy will be remembered, squinting
at the sunlight, his chubby hands
grasping at his doting mother's throat.

THE BAPTISM OF CHRIST
 —after Titian

He's discarded
his rather formal robes
of red and white

to receive the long-
awaited blessing
from brotherly Saint John.

A flock of angels
and the painting's patron
look on, well-satisfied.

But what's that in the middle
distance? A young woman
with her hands flung in the air

shouting
at three vultures bent
over some nameless carrion.

Run, Signorina, run!
You have to make them go away
before those up on the hill

turn and apprehend
the day is already spoilt,
the good news won't last long.

DEPOSITION

Like family members
in the emergency room
just after their son has died,

they sit pale and stunned.
They don't want
to discuss the crash.

How much he was drinking,
how fast he hit the curve—
it doesn't matter.

The monitors
are disconnected.
The doctors have cleared out

to allow a moment's silence.
Soon, calls will be required,
the news somehow

made bearable. Now,
only their collective
breathing counts.

Thus the great painters
of the Renaissance rendered
Christ taken down from the cross:

almost everyone huddled
together, ashen and hopeless,
eyes cast toward the ground,

resurrection unthinkable
to all but one foolhardy mortal
gesturing at the clouds.

THE CALLING OF SAINT MATTHEW
—after Caravaggio

So much of what illuminates us
 occurs in shadow: counting
coins in a room lit by a single
window, the company dim
 and shady, too—one dullard struggling

to tally up the silver, an old man
 in spectacles bent over the table
for a closer look, a rapier-wielding
 thug guarding the loot. Only the boy
 seems open to the Messiah's command

that all must change immediately.
 Certainly, the saint-to-be has not yet
perceived his fate. He points stupidly
at a co-conspirator, as if God
 couldn't spot a mustard seed

from Alpha Centauri, as if this story
 hadn't already concluded even
in the moment of its taking place—
the angel's whispered conjury,
 the executioner's glinting sword.

ALLEGORY OF THE DISCOVERY OF AMERICA
—after Jacopo Zucchi

What a grand place the New World was
 in the hundred years after Europeans
took the trouble to discover it!
The native goddesses like duchesses
 just risen from their baths,

yet still adorned with earrings
 and tiaras as they twirled their golden-
brown hair. The native men muscular,
adept at angling and handy
 with their bows. Blue sky

merged into the waves' gentle curl.
 The beaches were blanketed
with savory lobsters and scrumptious crabs
and every variety of seashell: nautilus
 and lightning whelk, cowrie,

scallop and conch, all impossibly
 beautiful and delicately whorled.
Coral sprouted everywhere, like spring
wheat in the fields of Tuscany.
 Even the monkeys wore strings of pearls.

A VISIT TO THE VATICAN MUSEUMS

i. In the Gallery of Maps

It's a long haul
from the Apollo Belvedere
to Michelangelo's
tour

de force, including four
hundred yards
of nasty
museum guards

and a crush
of sweaty mortals
pressing toward
the distant portal.

Along the way, the walls
are painted with charts
and surveys and plats
of no little art-

istry: the Papal grasp
on Italy
absolute,
evidently.

Every hill and cove
and burg from Calabria
to Emilia Romagna
to Lombardia

is documented in lingering,
proprietary
detail. Then someone shoves you—
there's no time to tarry

in this smothering
unimportant space:
down the corridor God,
in all His capriciousness, awaits.

ii. Sistine Chapel, July

There's nothing holy about this place,
 or if there is it's only the miracle
that so many people can be crammed
 so tightly together without brawling
 or fucking or forming a splinter government.

From his central spot in the ceiling,
 the Lord God, bearded and muscular,
looks down on us, his creations:
 the balding older woman who's dyed
 her hair bright red, the wawling baby,

the gossiping teenagers, the tour guides
 who won't shut up, the French guy
who keeps stepping on my foot—
 the entire seething, sweaty mess He set
 in motion with his outstretched fingertip.

iii. Uscita

Little philistines, they dash
 down the spiral exit ramp
after hours spent nearly
 perishing in the Vatican
Museums, one masterpiece
 after another shoved
down their callow gullets.
 At last it's over!
They are merely teenagers
 again, free to skip over
safety bumps, jubilantly
 ignoring the warnings
not to run, hollering,
 punching, giggling, spitting
out into the street where
 they know the real art
of living is always done.

The Question of Temporality in Renaissance Painting

Time doesn't matter when all Eternity
is perpetually at hand. Just look

at the way a single canvas can contain
ill-tempered Saint Jerome

frowning at willowy Saint Sebastian,
Saint Francis preaching to his birds,

and Saint Gabriel hovering over everything,
wagging his finger, as Saint Joseph

stares down at his own unclad feet.
Swallows and goldfinches trill

and twitter in skies thick with angels
while Mary sits patiently, gracefully,

Everlastingness nestled like a promise
in the lapis lazuli folds of her lap.

Ecstasy

After months spent wandering
through the great picture galleries

of Rome, one can't help but envy
the ecstasy of saints. One

moment they're spooning
carrot soup into their mouths;

the next, they're tumbling
helplessly to the floor, eyes

rolling back in their heads, angels
at their sides to ease the sweet

terror. Everything that mattered
that morning is meaningless:

misbehaving family members,
money owed to others or themselves,

prayers and sins and that missing
scapular, it's all ancient

history now the spirit's entered
them like water filling hollow earth,

their vision become blurry, brains
abuzz with extravagant ideas

that neither they, nor we,
can ever hope to truly follow.

Votivo

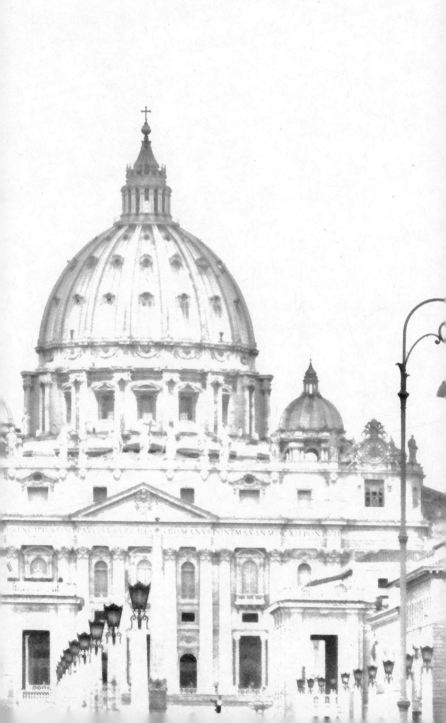

THE SON OF MAN GOES TO CHURCH

The Son of Man wishes He couldn't hear every prayer uttered aloud or silently.

He's like that boy in the movie who sees dead people—it's a curse, but what are you going to do?

Therefore, He avoids religious holidays.

Sundays, too, when He can.

And He doesn't fancy cathedrals or basilicas.

The vague echoing of footsteps and voices, like someone else's memories.

He's unimpressed by gilt and marble angels.

He despises the private chapels with their ostentatious donors painted into the holy scenes.

No, give the Son of Man a tiny, far-away church with an honest priest and a smattering of old women dressed in black.

Give him real candles, not these electric things.

He prefers Latin but doesn't mind the flowery King James English or the rhythmic surge and ebb of Greek.

Silence is supreme.

Still, even in the quietest, most reverent places, He's apt to feel a chill, an unpleasant tingling down His spine.

He's never sure if it's the preponderance of stone.

Or something infinitely sadder.

THE ECSTASY OF SAINT TERESA
—after Bernini

Eyes-half blind
with a pleasure that reaches
past her soul

into her marrow,
the young nun of Ávila,
helpless on her cloud,

cannot decide which pain
is more provocative:
the angel withdrawing

his golden arrow
from her fiery belly,
or the anticipation

of the next thrust,
deeper
and more savage.

Heaven's light beams down
in rays as thick
as bronze, and the world

looks on, though we sinners
are nothing
to a saint. She is alone

in her rapture,
. the way to God
bituminous and self-

absorbed—the entry
wound secret
and narrow.

A Primer on Sculpting Pietàs

Mary should be about as old as she
Was at his birth, mid-twenties at the most.
Though sprawling, he should fit comfortably
On her lap. His giving up the holy ghost
Must be an elegant, soft-sell affair:
His head should have a sleeper's pose, the hands
Arranged with a mortician's muted flair.
Do what the interior light demands.
There should be robes, of course. A crown of thorns
Is optional. Go easy on the blood.
To test effectiveness, ask one who mourns
Regularly to touch the stone or wood.
If the scene is suffused with a faint light,
Congratulations, you've done it right.

THE TRIUMPH OF FAITH OVER HERESY
—Pierre Le Gros the Younger, Santissima Nome di Gesù

How helpless they look, Martin Luther, nailer
of doctrines to church doors, and Jan Hus, who donated
his body to one of several hundred thousand
purifying fires kindly kindled by the Catholic Church.
They're practically falling off the altar, limbs
jumbled in their gowns, halfway to hell
already as they flinch from Mary's upraised
cross of gold and steady look of disdain,
the little cherub in the corner tearing up their book
of lies. Tourists pause briefly in their babel
of beliefs, searching for the appropriate *Blue
Guide* page, or simply turning away in boredom—
there is so much to see in the Eternal City
it hardly pays to linger long beside this scene
of one more foregone parable, set in stone.

Nuns in Rome

So wonderful to see them here
 in their gray wimples and habits
and sensible shoes, giggling
 like the schoolgirls whose hands
they're obliged to slap, delighted
 when some tourist deigns
to take their photograph
in front of Saint Peter's
 or the Pantheon. Most

 seem to be visitors, like me,
 stockpiling memories
of the Eternal City against
 their inevitable return
to Nairobi or Bratislava
 or Asunción. Heavy work
awaits them—dictators
and poverty and ravenous priests
 who cannot wolf down

 the local lads fast enough—
 but for the moment shafts
of sunlight slice occasionally
 into the narrow streets, or shine
on the piazzas where boys
 kick soccer balls at the walls
of the ancient churches—Santa Barbara
dei Librari, Chiesa Nuova, la Basilica
 di Santa Maria del Popolo.

Wax Monk in a Glass Box

I forget the church—somewhere
 in Trastevere, I think—where we saw
 the wax effigy of a monk
resting his eternally sleeping head
 on a silk pillow. It was a well-lit coffer,

 and he looked peaceful enough
 in his robe and sandals, his cincture
 loose and comfortable.
He carried a Bible and a crucifix
 and a rosary for the journey

 skyward, and for a moment
 I felt simple-minded
 enough to believe I was looking
at a semblance of the truth:
 the candles burning for the dead

 were beacons, and the angels painted
 on the ceiling were singing just to me.
 Then the church door opened,
and a couple walked in loudly speaking
 German. I noticed his hair

 was made of nylon, and I thought
 how like a sideshow attraction
 this contrivance would seem
even in America, that other land
 where lies are tarted up as dreams.

SAN CALLISTO

In the lush fields
above these dank

catacombs
where Barbarians

came to smash
the marble tombs

and fragile bones
of Christians,

a flock of sheep
is grazing,

each one tagged
in the left ear,

their thick coats ripe
for shearing.

Figure on a Marble Sarcophagus

All one
ever needs

to know
about death

is inscribed
on his

face: weak
chin and

sour mouth,
big ears

and Roman
nose, those

heavy-lidded
eyes—pitted

now by
time—gazing

down at
nothing forever.

In the Capuchin Crypt

Thank God for the friars
who bequeathed
their better selves

to these musty chapels
now tessellated
with their clavicles

femurs and scapulae,
whose very skulls grin
at this grotesquerie

of piped-in organ music
and campy souvenirs,
who—praise them!—

have shown Death up
for the folly we've always
suspected it must be.

A Wedding in Santa Maria in Aracoeli

The chandeliers are all alight, bouquets
 of white roses decorate the nave, but this young
couple—he in his tuxedo, and she in a dress
 that seems to fill up half the apse—
 apparently aren't powerful enough to keep
the doors locked for the ceremony. We
 intruders wander in and out in backpacks

and baseball caps, annoying
 family members by taking flash
pictures of the crucifixions and the bride
 and groom sitting straight-backed before
 the priest, who's bent over a microphone,
haranguing them about the proper roles
 of man and wife. It doesn't sound much fun,

so I check out Pinturicchio's pinch-faced Saint
 Bernardine pointing at the ornate coffered ceiling,
and Cavallini's gilded Madonna, and a copy
 of the stolen Santo Bambino, that jewel-
 encrusted doll of miracles, and the marble
statue of frog-faced, malarial Leo the Tenth,
 hawker-extraordinaire of indulgences.

What a trove of implausibilities!
 The priest is still preaching about the couple's long,
long life together when I slip out
 from the solemnity into the splendidly muggy,
 exhaust-laden air, the one hundred twenty-four
steep steps leading back down to Rome
 like a bridal carpet laid out at my feet.

Blurry Night-time Photograph
of Saint Peter's Cathedral

It might be any gaudy mansion,
even a state capitol—nothing

to indicate the world once altered
itself within these quivering

white columns, beneath the unfocused
blue-gray cupola. Brake lights

bleed into one another, unreadable
road signs shimmer. The sky's

as Black as Milton's Hell, though
someone appears to be waving

from the window of a bus: ghost-like,
with a prophet's inscrutable face.

At the Beatification of Pope John Paul II

I'm up far too late to stake
a place in Saint Peter's Square,
so I linger here

on the great crowd's fringe
by Castel Sant'Angelo, one-
time fortress of the popes.

In yellow scarves
and yellow hats, pilgrims
sit on camp chairs listening

to loudspeakers pipe in
the ceremony, cameras
and boxed lunches and plastic

pennants strewn about
their picnic blankets.
Occasionally they stand, craning

their necks for a glimpse
of the nearest JumboTron TV,
but it's difficult to see

anything except the heads
of other people and the flags
of many countries, all gone limp

on this windless morning.
A nun, white as the saint-to-be's hair,
gets her blood pressure checked

in the Red Cross tent. A helicopter
circles overhead. The old man
next to me lights a cigarette,

mumbles something in Polish,
sighs heavily as he blows
the smoke out through his nose.

PASQUETTA

A husband and wife from Topeka
emerge from their hotel lobby,
stunned by the silence.

The Resurrection's over
and the streets of Rome are empty
for Little Easter holiday.

Where are the taxis and the beggars,
the street vendors and the touts?

Where in the world is everyone?

On the Via dei Coronari
light rain on the cobblestones.

Light rain dripping from the eaves.

Their guidebooks useless now,
they pause in the Piazza dell'Orologio
gazing upwards for guidance.

Alas, the handless Borromini clock
hasn't told time in years.

Tuesday Afternoon Mass in the Capella Paolina

Though a sign in three
languages clearly forbids
gawking, I cross
into the sanctum and take

a seat in a back pew.
Impossible to resist
the silver-haired priest's
deep and soothing

Italian, the toothsome
angels and welcoming
saints, the painted scenes
of sacrifice and ascension.

For half an hour I revel
in the mystery.
Then a line begins to form
for communion,

and though I'm almost sold
on this sonority, I know
I must leave: the incense
has dissipated, and I've no

right to approach the linen,
white as fleece, covering
the altar. This alien blood
and body aren't for me.

Votive

I swear to God, David, I think I've lit
 a candle for you in every church in Rome—
 in Santa Maria di Maggiore
 and Santa Maria in Trastevere
and Santa Maria degli Angeli
 and Santa Maria della Consolazione
 and half a hundred others—long slender candles
and squat ones with wicks that sputtered out,
 and when the candles were electric lights,

I've dropped a coin in the *Offerta* box
 and flipped the switch for you. I've lit candles
 in churches where I was the only living soul
and in basilicas thronged with tourists
consulting Rick Steves on which chapel,
 exactly, one ought to photograph.
 I've lit candles during mass and in the midst
of lectures in all the major Romance languages,
 as well as Japanese and Mandarin.

Footsteps squeak and echo in the nave and aisles,
 someone tries to mute a cough, the exit doors
 slam shut—the world continues, untroubled
 by your absence—yet I have stood
by those small flames, godless, prayerless,
 but faithful to your memory nonetheless,
 as steadfast as the cardinals and noblemen
whose marble effigies keep vigil
 on their all but unremembered bones.

Circo Massimo

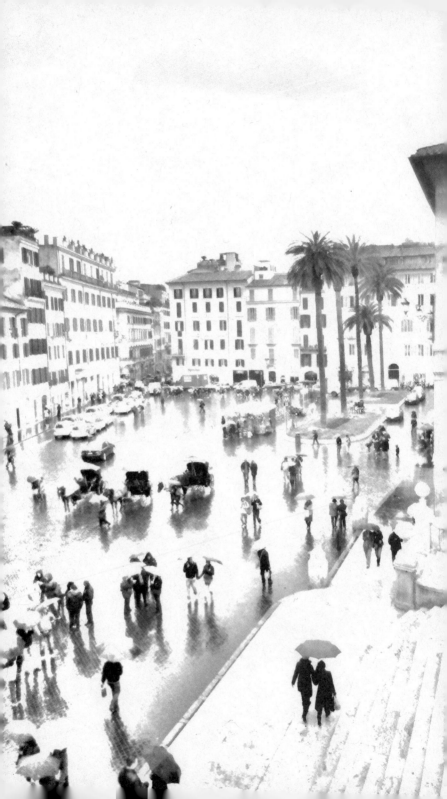

The Son of Man, Peripatetic

He's always liked walking, and what better place to do it than here,
 His home away from home?

Day and night, He treads the Rioni: Ripa and Borgo and Trastevere,
 Sant'Eustachio and Prati and Testaccio.

He stops at flea markets to patronize His fellow immigrants: fake
 designer sunglasses, an *I ♥ Roma* T-shirt, a pair of women's
 underthings.

He steps in dogshit.

That's okay: dogs are God's creatures, too.

A scooter nearly runs Him over on the sidewalk.

All is forgiven: just don't do it again.

When He's tired, He rides the Metro, back and forth from Rebbibia
 to Laurentina, swaying with the impassive crowds.

On the tram, He tips the accordion player a euro, maybe two.

On the bus, He always offers up His seat to nuns.

At night, He watches the lovers smother one another on the park
 benches of the Villa Borghese.

He stands outside the nightclubs and hums what He knows of this
 year's songs.

It's a lonely, rootless sort of afterlife—not what He, or anyone, would
 have predicted.

Is that puke or gelato on the pavement?

Is the city afire, or is it only the coming of dawn?

A baker smoking in the alley offers Him the bread that didn't fully
 rise this morning, and He stuffs it greedily into His blessèd
 mouth.

PALELY LOITERING
 —For D.C.

Looking out on the Spanish Steps
from Keats's final room,
February, a few days

after the anniversary of his death,
I think, of course, of you, my friend,
another great poet little

appreciated in his lifetime.
Outside, a volley of showers.
Half a dozen men hawking

umbrellas amid the tumult
of a dozen languages,
Dior and shouting teens

and the flash of tourist
cameras. I would describe
for you the light green curtains,

the chair in the corner,
the silk upholstered bed,
but these are only approximate

replicas—Vatican law decreed
the contents of all sick rooms
be burnt upon their occupant's

demise. The famous death mask
is there, however, enclosed
in Plexiglas, and in the piazza

a horse waits with its carriage.
The driver's dressed in black.
The horse nickers in the rain.

Il Cimitero Acattolico di Roma

There's a gap in the brick wall
for picture-taking tourists

who can't be bothered to walk
through the gate and back to the grave

of *One Whose Name Was Writ
in Water*, but plenty still make

the trek, so it's difficult
to commune in silence

with the great poet of quiet
thought. Ultimately, I give up.

Elsewhere, the resting place
of Antonio Gramsci is crowded

with well-wishing fellow travelers,
William Wetmore Story's *Weeping*

Angel receives lots of company,
even Goethe's son gets a little

play. Yet Shelley's well-tended
slab is unvisited for half

an hour, time enough for a black
and white cat to leap down

onto the warm marble and fall asleep.
As he purrs softly in the Roman sun,

I feel a sudden rush of panic,
as though I had forgotten

some crucial errand in the wilderness
it's too late now to execute.

I look stupidly at my watch: nine days
since your unthinkable death,

The Italian Man of Letters

In every room, his thousands of books rise
 in shelves that reach the sixteen-foot high
ceilings like monuments to a vanished
culture: art predominates (his passion,
 not his profession)—the Renaissance

and its many triumphs, monographs
 on Etruscan sculpture, Doré's engravings
of the *Divine Comedy*, catalogs
from recent exhibitions in Venice,
 Turin and Milan—though there's an entire

room of austere paperback translations
 of everyone from Goethe to Saint John
of the Cross to Stendahl to Steinbeck, and odd
tomes dot the stacks: an alegebra textbook
 from 1959, a thick Serbian

manual on astrology, *The Illustrated History
 of Vogue*. Bound journals fill half
a dozen walls—*Ideazione* and
Il Foro Italiano and *20'*
 Secolo and *Comunita* and

*Annuario di Politica
 Interna Zionale*. His own books
are scattered throughout the flat, afterthoughts,
perhaps. Naturally, he hasn't updated
 the décor since the early 70s,

so new guests feel as though they are walking
 into a late Fellini film, minus
the beautiful women. Couches sag, light bulbs
aren't replaced. Tiny beds inhabit
 forgotten rooms; here and there a model

Ferrari, a dusty china doll—signs
 of children who long ago abandoned
 ship. If women were a permanent part
of his life, the place would have been remodeled
 many times, but he's satisfied

 with casual flings, the occasional
 long-termer who, like him, prefers her own
 savagely idiosyncratic space.
And so he sits in his study, looking down
 on the shadowy Tiber, an indifferent

 bottle of red wine beside his laptop—
 typing, stopping, typing more. Finally,
 this is all that matters: his thoughts coming
loudly but intermittently, interrupting
 the silence, like Roman traffic at 2 a.m.

ORA DI PUNTA

Every street at a standstill.
The only thing moving
the Vespas on the sidewalks

and the pedestrians
leaping
to get out of their way.

The petition
of a thousand car horns
like a litany of prayers.

Somewhere in his palace,
the Pope snoozes
between decrees.

On the Ponte Vittorio Emanuele,
a beggar woman presses
her face against the paving stones.

Above her, an angel,
its bronze wings outspread
against the leaden sky.

Beneath the Ponte Umberto I

It's a multicultural gathering beside the Tiber
on this cold February evening: five Ghanaians,
their knock-off Gucci and Prada bags
always within arm's reach, three Bangladeshi
sellers of Taiwanese camera stands, two Swiss
backpackers short on cash, and me, huddled
around a trash fire while the *ora di punta*
traffic bleats and guns and muddles above us.
One of the Swiss lights a joint and around
it goes. One of the Ghanaians has a guitar
with a missing B string, but still he can play
"No Woman No Cry." For a moment, I sense
we've all been sitting here for eternity,
untouched by the Romans and their hermetic
business—trading indulgences, betraying
one another with the icy passion of their God—
while the hireling river, malodorous
and wide, trundles its debris like a junkman
toward the lenient, once-important sea.

TRE OSSERVAZIONI

1. *The Consequences of Being Late in Italy*

None, so far.

<center>⋯⋯</center>

2. *Reading* The History of the Decline and Fall of the Roman Empire *in a Café on the Via Belsiana*

Perhaps Gibbon's conclusions were a tad premature.

<center>⋯⋯</center>

3. *To the Birds on Lungotevere dei Mellini Trying to Sing Above the Traffic Noise*

Good luck!

To the Sycamore Trees Along the Tiber

Who can resist a smiling young nun hurrying beneath
your sheltering branches on her first visit to the Vatican?
The weather's sweltering, the noisy streets
are crowded with the heirs of former conquerors—
someday she may be disappointed, but she isn't yet.

<div align="center">❦</div>

Red and copper leaves dot the river like stippled paint.
A transvestite on Lungotevere De' Cenci pauses to light
a joint and bask in the still warm breeze soughing
through your vanishing umbrage. The young priest
in his pressed cassock pauses to whisper in her ear.

<div align="center">❦</div>

Now the wind has turned bitter, the spiky balls
of seeds suspended from your bare branches sway
erratically, but never fall. You no longer cloak
the aging apartments on each side of the river. At night,
the occupants strain for a glimpse of one another.

<div align="center">❦</div>

Your new leaves appear overnight and seem to double
in size each pleasant April day. The nuns are back,
as are the tourists. You inhale the exhaust of Vespas
and Smart Cars, exhale your own mild breath.
The transvestite is back, too—older, but still alive.

TIBER STAIRS

If you descend to the ancient river
 At night with your lover to steal a kiss,
Especially when the moon is absent,
 Be careful to avoid the shit and piss.

THE GARBAGEMEN OF ROME

Such *sprezzatura* they have in their orange jumpsuits!
With their well-coiffed hair and agile sidesteps

and gallant asides to the ladies, they might
as well be fencing on the battlements

of the Castel Sant'Angelo, or dancing a quadrille
on the marble floor of a palazzo, as going round

collecting trash. This Wednesday morning,
the driver of a streetsweeper noses down

the cobblestoned street, singing an off-key aria
out the open window. His partner—*cornetto*

in one hand, a twig broom in the other—jabs
distractedly at trash beneath the tables and chairs

of the sidewalk cafés. They miss a lot,
but together they manage to nudge most

of the wilted lettuce and trampled fliers
and cigarette butts out of the way. *Che importa?*

What they don't pick up today will be here waiting
for next week's bravura performance. *Da capo! Encore!*

FONTANA DI QUATTRO FIUMI

How comic Bernini
found the great rivers
of the world! The portly

Ganges slouching
on his rock; the Danube
with arms outstretched,

legs akimbo; the bald-
headed Río de la Plata,
tilted back as if roaring

drunk, about to topple over;
and the Nile, so afraid
of everything he's draped

a blanket over his face.
Perhaps this Baroque
in-joke is a figure

for the very fountain-
head of ideas: where pratfalls
beget resplendent art

and even the gods
are not exempt
from sitting naked

in a gawking crowd
with pigeons
shitting on their heads.

THE RAPE OF PROSERPINE
—after Bernini

Though she struggles
heroically, head thrown
back, arms flung out

toward her absent mother,
the Lord of the Underworld,
bearded and buff,

his right hand
gripping her left thigh,
never plans to let her go.

Cerberus, on three-headed
guard, howls and sniffs
and growls at his master's naked

lust, as evening fills
with the rich smell of earth's
first withering. Surely

this *figura serpentinata*
of a bond, spiraling from Sicily
down to hell, augurs more

than merely winter. Listen
to her clenched-jawed call for help.
And his reply of silence.

SPRING COMES TO ROME

The cherry trees are flowering in Prati.

The Tiber's turned a slightly less
noisome shade of greenish-gray.

The lilt of vowels is louder, happier,

yet somehow more alarming. The tide
of tourists has turned into a tsunami.

Fashions, of course, have already changed.

A coldish man unexpectedly kisses

his ancient mother, as the last chestnut
vendor on the Corso douses his flame

and wearily puts his wares away.

Thunderstorm, Piazza Navona

The place was packed five minutes ago
 and now it's all but empty—rain pounding
the cobblestones, late April wind
 lifting the tablecloths like women's skirts.
 The painters have wrapped their water-
colors of the Colosseum and the Pantheon
 in plastic tarps, stowed their caricatures

of Berlusconi and Will Smith in plastic
 totes. The refractory pigeons huddle
under the eves, and the Four Rivers
 Fountain, unattended by picture-takers,
 flows a little more easily. The Bangladeshi
umbrella salesmen are having no luck:
 everyone's already drenched, or covered.

Meanwhile, those of us safe beneath
 the canopies of the restaurants
nurse our eight euro beers and watch
 the *Polizia Municipale* in their tiny Fiat
 circle the square, while lightning
crackles over Rome and dazed afternoon
 light lingers in the unexpected air.

CIRCUS MAXIMUS

Nothing now but grass
and gravel
and windblown trash,
a vacant lot drab
and austere,
where once, in a single day,
you might delight
in the death
of three or four charioteers.

Coda:
Le Porte di Corno e Avorio

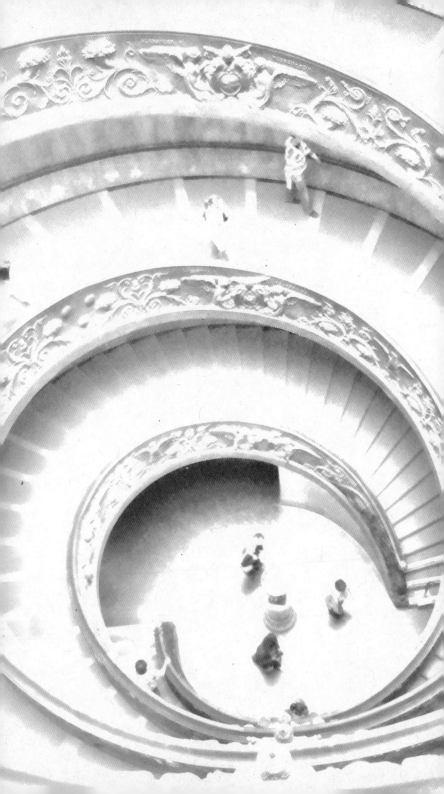

THE GATES OF HORN AND IVORY

Sunt geminae Somni portae....
 —Virgil

Perhaps it was all a dream, like the eighth
season of *Dallas*, or Aeneas's
misguided vision of Thrace. Maybe I never
left my home on this California hilltop
to walk the alleys of Rome, but only drowsed
on my couch while Sleep dispatched false
emissaries from the underworld to dupe me
into believing I was there amidst
the golden ruins. Just yesterday
I would have sworn to you I once sat
in the pews of Santa Maria di Maggiore
listening to Mass, that I joined in
on the chorus of "Wish You Were Here"
with the hippies on the Spanish Steps,
that when the guard in the Villa Borghese
turned his eyes I traced the spiraling horn
of Raphael's unicorn with my fingertip.
Even last night I seemed to hear the Ducatis'
roar and the siren of an ambulance
hastening down *Lungotevere dei Mellini*
and *Vaticano* and *Giancolense*
all the way to the *Ospedale*
Fatebenefratelli—someone hurt
or dying. And yet I open my eyes now
to a silence broken only by the intermittent
twittering of birds...and then the TV flaring.
Cue the announcer's sonorous voice waking
America to another restive morning.

Acknowledgments

The following poems have appeared in publication previously: "The Italian Man of Letters" (*Antioch Review*), "The Deluge" (*Connecticut Review*), "The Ecstasy of Saint Teresa" (*Connecticut Review*), "The Garbagemen of Rome" (*Cordite*), "Votive" (*Crab Creek Review*), "The Question of Temporality in Renaissance Painting" (*Crannóg*), "Fontana di Quattro Fiumi" (*Hart House Review*), "Wax Monk in a Glass Box" (*Hart House Review*), "Nuns in Rome" (*Literary Imagination*), "Ecstasy" (*Los Angeles Review*), "A Primer on Sculpting Pietàs" (*Measure*), "Sistine Chapel, July" (*Owen Wister Review*), "Deposition" (*Southampton Review*), "Palely Loitering" (*Southampton Review*), "Uscita" (*Southampton Review*), "Judith and Holofernes" (*Southern Review*), "The Rape of Proserpine" (*Southern Review*), "Allegory of the Discovery of America" (*Southern Humanities Review*), and "A Wedding in Santa Maria in Aracoeli" (*Tar River Poetry*).

ABOUT THE AUTHOR

PATRICIA HOUGHTON CLARKE

David Starkey served as Santa Barbara's Poet Laureate from 2009 to 2010, and he is the founding Director of the Creative Writing Program at Santa Barbara City College. Among his poetry collections are *Fear of Everything*, winner of Palanquin Press's Spring 2000 chapbook contest, *David Starkey's Greatest Hits* (Pudding House, 2002), *Ways of Being Dead: New and Selected Poems* (Artamo, 2006), *Starkey's Book of States* (Boson Books, 2007), and *It Must Be Like the World* (Pecan Grove, 2011). *A Few Things You Should Know About the Weasel* was published by Biblioasis in 2010, and two poems from the book were subsequently featured on Garrison Keillor's *A Writer's Almanac*. In addition, over the past twenty-five years Starkey has published more than 400 poems in literary journals such as *Alaska Quarterly Review, American Scholar, Antioch Review, Barrow Street, Beloit Poetry Journal, Cincinnati Review, Georgia Review, Massachusetts Review, Notre Dame Review, Poetry East, Southern Review, Southern Humanities Review,* and *Southern Poetry Review. Creative Writing: Four Genres in Brief* (Bedford/St. Martin's, 2012) recently went into its second edition and is currently one of the best-selling creative writing textbooks in America.